DAD

I WANT TO HEAR YOUR STORY

101 Father's Guided & Keepsake Journal To Share His Life & His Love

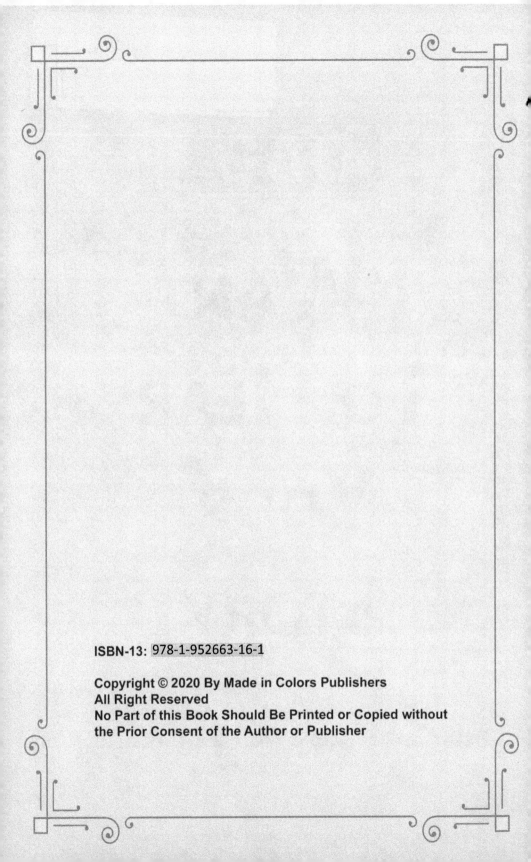

ISBN-13: 978-1-952663-16-1

"

Dad when I count
my blessing,
I count you twice.

An Irish blessing

to: _____

from: _____

My Great grandfather My Great grandMother

My grandDad & Mom My grandDad & Mom

My Father My Mother

My Family Tree

1. What Day of the Week were you Born?

2. what is your full birth name?

3. What's your earliest memory?

4. What did you have as a child that kids today don't have?

5. What comes to mind when you think about growing up in your hometown?

6. What are your memories about the houses you lived in as a kid? Did you have a favorite?

7. What did you have or play with as a child that Kids don't have today?

8. What was your favorite book or movie when you were my age?

9. What did you think you wanted to be when you grew up?

10. What do you think was the dumbest thing you did as a child?

"

A good father is one
of the most unsung,
unpraised, unnoticed,
and yet one of the
most valuable
assets in our society.

Billy Graham

11. What was the most difficult thing you went through as a child?

12. What are your strongest memories of your mom (grandma)?

13. What are your strongest memories of your dad (grandpa)?

14. What is the best thing your parents ever cooked?

15. What's something your mom or dad used to tell you growing up that later turned out to be true?

16. What is the most embarrassing thing your mother or father ever did to you?

17. Did you have pets growing up? Tell me about them.

18. What are your favorite memories of family gatherings?

19. What was a favorite family tradition when you were growing up?

20. How are you most like your parents? How are you different?

"

Any man
can be a father,
but it takes
someone special
to be a Dad.

Anne Geddes

21. Who was your best friend in elementary school? In high school?

22. Did you ever win an award? What was it for?

23. What were your favorite things to do as a kid?

24. Who was your childhood hero?

25. What's the first album or CD you ever bought?

26. What did you love to do in high school?

27. Were you ever on any teams or play any sports?

28. What do you remember most about being a teenager?

29. What world events have had the most impact on you?

30. How did you meet Mom and knew she was the one?

❝

Any fool can have a child.
That doesn't make you
a father.
It's the courage
to raise a child
that makes you a father.

Barack Obama

31. Where did you go on your first date?

32. How did you choose your career? What do you like most about it?

33. What made you successful at work?

34. What advice do you have for your children about what to focus on in our careers?

35. What do you remember about when each of us was born?

36. What's the best gift you've ever received? What's the best gift you've ever given?

37. What lessons have you learned about other people in life?

38. Tell me about the three best decisions you've ever made.

39. What is your biggest accomplishment?

40. What are you most proud of in life?

"

It doesn't matter
who my father was;
it matters who
I remember he was.

Anne Sexton

41. What are the three happiest moments in your life so far?

42. Is there something you've always wanted to do or experience that you haven't had a chance to yet?

43. What do you think the world needs more of right now?

44. What is the best advice your dad ever gave you?

45. What are you most thankful for?

46. What has been your favorite age so far, and why?

47. Is there anything that you wish you had asked your parents but haven't/didn't?

48. What was your favorite movie or book when you were my age?

49. What was the hardest thing you went through as a child? How did you overcome it?

50. What is the most embarrassing thing your mother or father ever did to you?

66

My father didn't tell me how to live. He lived and let me watch him do it.

Clarence Budington Kelland

51. What is the best thing that your grandparents ever cooked? What about your parents?

52. What three adjectives would your grandparents use to describe you?

53. If you could go back to one day in your childhood, which day would that be? Why?

54. How are you most different from your parents and grandparents? How are you the same?

55. What did your grandparents do with you that you loved?

56. What did they do that you didn't enjoy so much?

57. What do you wish you spent less time doing when you were my age?

58. What surprised you the most about being a dad?

59. Who taught you how to drive?

60. At What Age did you learn how to drive?

> "There is no teacher equal to mother and there's nothing more contagious than the dignity of a father.

Amit Ray

61. Have you ever broken the law?

62. What's the best piece of advice anyone's ever given you, and what prompted the advice?

63. What's the best meal you've ever had?

64. What's the maddest you've ever been?

65. Is there a memory from high school that makes you cringe?

66. How do you see me 10 years from now?

67. Is there a song that changed your life?

68. When you were growing up, what's one thing you wanted to change about the world?

69. If you had $20 as a kid, what would you spend it on?

70. What have you learned about communication and relationships through the years?

66

I cannot think of any
need in childhood
as strong as
the need for a
father's protection.

Sigmund Freud

71. What was the hardest year/decade of your life so far?

72. How did you change from 20 to 30 years old and 30 to 40 years old?

73. When was the last time you got goosebumps from an emotional experience?

74. What can make you cry?

75. What have you changed your mind about since you were young?

76. What do you most regret in your life?

77. What was your biggest fear as a parent?

78. What is your purpose for being here?

79. In what ways is your life different than you imagined it would be?

80. Did you feel pressured to provide for the family, and how did that affect you?

"

The older I get, the smarter my father seems to get.

Tim Russert

81. What did you really think about Mom the first time you met her?

82. Who was your greatest influence and why?

83. What is the dumbest thing you ever did?

84. What has been the most exciting time of your life?

85. What talent do you wish you had that has eluded you?

86. What gives you the most joy?

87. When did you have your first Kiss? Who did you have it with? Did you like it?

88. At What Age did You Lose your Virginity

89. What is your favorite joke? Why?

90. If you could afford any car in the world, what would it be?

66

A father is
someone you
look up to
no matter how
tall you grow.

Unknown

91. What kinds of scenes in movies make you cry?

92. Is there any experience that you have not had that you regret not having?

93. How would people who knew you in high school describe you?

94. Have you ever done something brave? If so, did you regret it?

95. How many times have you been in love?

96. Did you ever wish you didn't have children? If so, what made you think that?

97. Have you ever gotten Drunk? Tell Me About It

98. Did you ever get jealous of someone?

99. Have you ever thought of adopting a child? Why or why not?

100. What is the thing you wanted most that you haven't gotten?

"

Daddies don't just love their children every now and then, it's a love without end.

George Strait

101. Looking Back , What Would You Do Differently in Your Life?

Note

Note

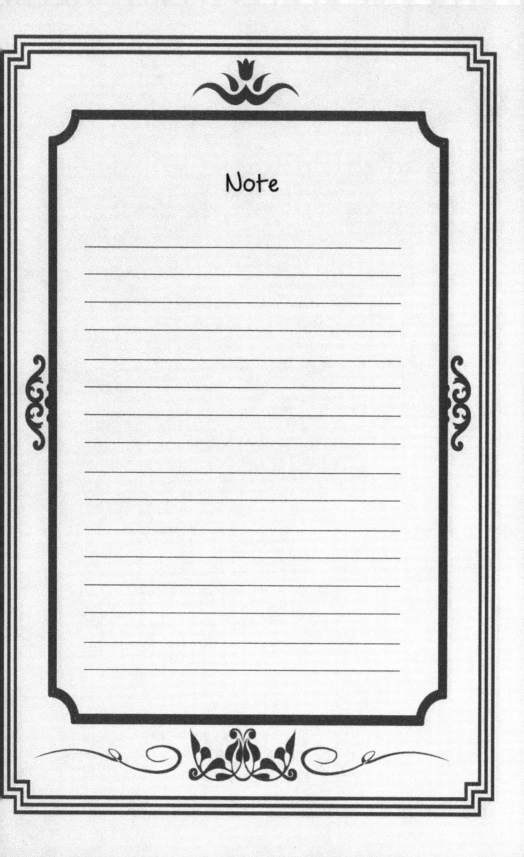

Note

Note

Note

CPSIA information can be obtained
at www.ICGtesting.com
Printed in the USA
BVHW091228290621
610728BV00006B/1819

9 781952 663161